INSTANT WALL ART:
vibrant
botanical prints

45 Ready-to-Frame Illustrations
for Your Home Décor

Adams Media

New York London Toronto Sydney New Delhi

Adams Media
An Imprint of Simon & Schuster, Inc.
100 Technology Center Drive
Stoughton, Massachusetts 02072

First Adams Media trade paperback edition April 2023

ADAMS MEDIA and colophon are trademarks of Simon & Schuster.

For information about special discounts for bulk purchases, please contact Simon & Schuster Special Sales at 1-866-506-1949 or business@simonandschuster.com.

The Simon & Schuster Speakers Bureau can bring authors to your live event. For more information or to book an event contact the Simon & Schuster Speakers Bureau at 1-866-248-3049 or visit our website at www.simonspeakers.com.

Interior design by Colleen Cunningham and Priscilla Yuen
Interior illustrations © 123RF/Channarong Pherngjanda, Olga Korneeva; Getty Images/bauhaus1000, NSA Digital Archive, duncan1890, ivan-96, THEPALMER, Olga_Korneeva

Manufactured in China

10 9 8 7 6 5 4 3 2 1

ISBN 978-1-5072-2027-6

INTRODUCTION

Today, beautifully colored botanical prints are showing up everywhere you look—from social media to popular design websites and magazines to the walls of your friends' bedrooms and kitchens. And now, instead of having to choose between one or two expensive prints, you can choose from forty-five stunning illustrations found within the pages of *Instant Wall Art: Vibrant Botanical Prints* to personalize your own walls!

Extraordinarily popular in the eighteenth and nineteenth centuries, these types of prints were first drawn and hand-colored by botanists who used gorgeous shades of watercolors to capture the scientific details of the flora they studied. Now, with images ranging from the trumpeting amaryllis to bold caladiums to the classic peony to cheerful lemons ripening on the branch, you're sure to find something in this book that speaks to your design aesthetic.

These images work well either placed alone in a featured spot or arranged in a group as a visually interesting gallery wall. All of the prints measure 8" × 10" and will fit in a standard mat and frame once removed from the book at the perforated edge. Some of the prints can be hand-trimmed to fit 5" × 7" or 4" × 6" frames. After removing the print from the book, use sharp scissors or a craft knife and follow the cutting lines found on the reverse side of the print to trim it to the desired size. Each cutting line indicates the corresponding frame size for easy selection and framing. So choose the prints you love, hang them on your walls, and enjoy the enchantment of nature in your own home throughout the year!

THE PRINTS

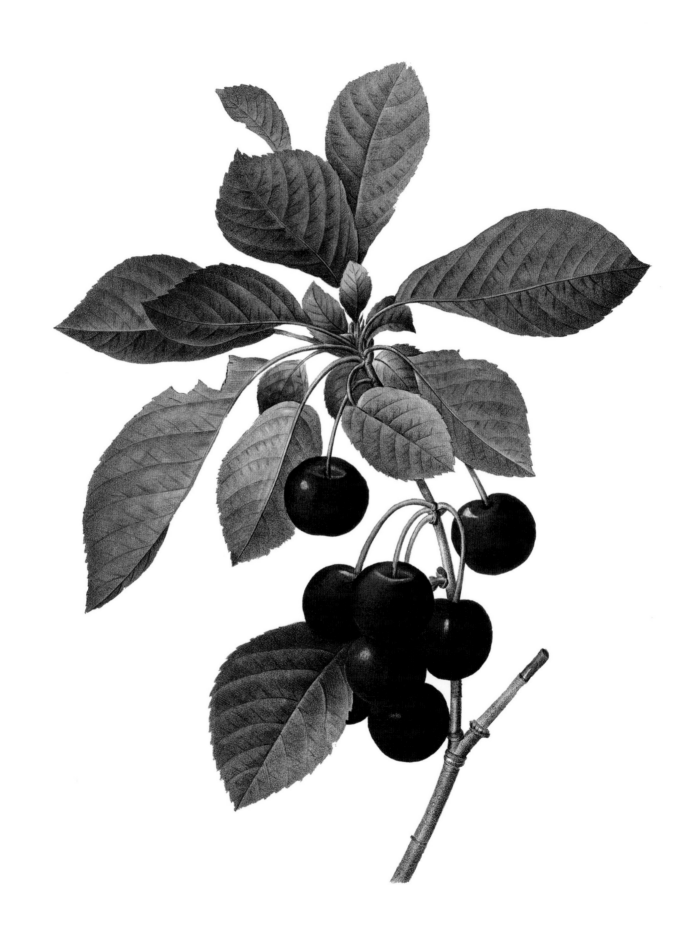

8" × 10"

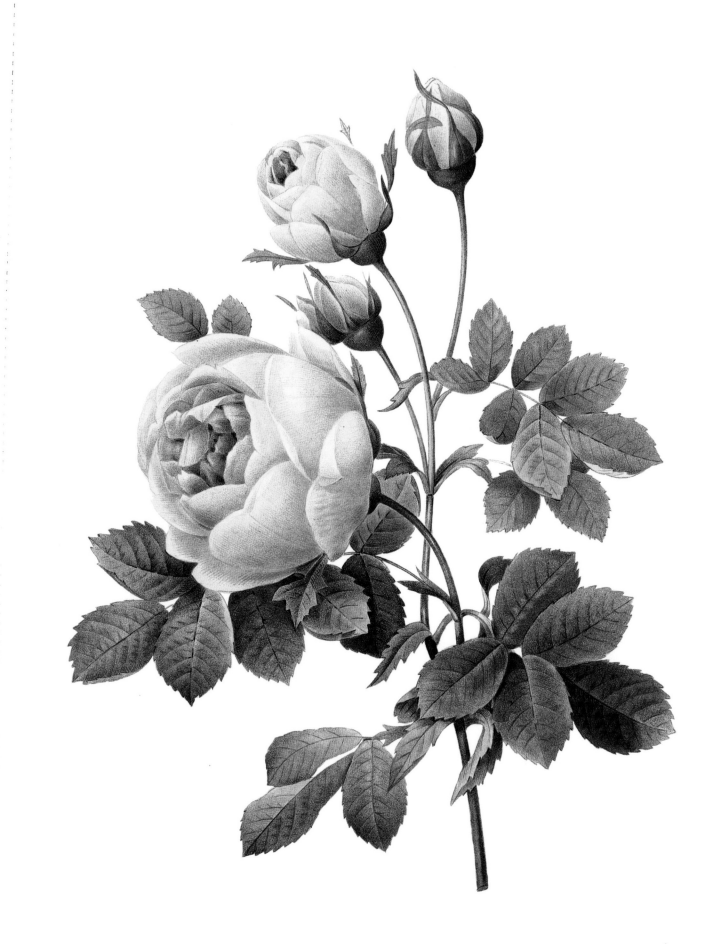

8" × 10"

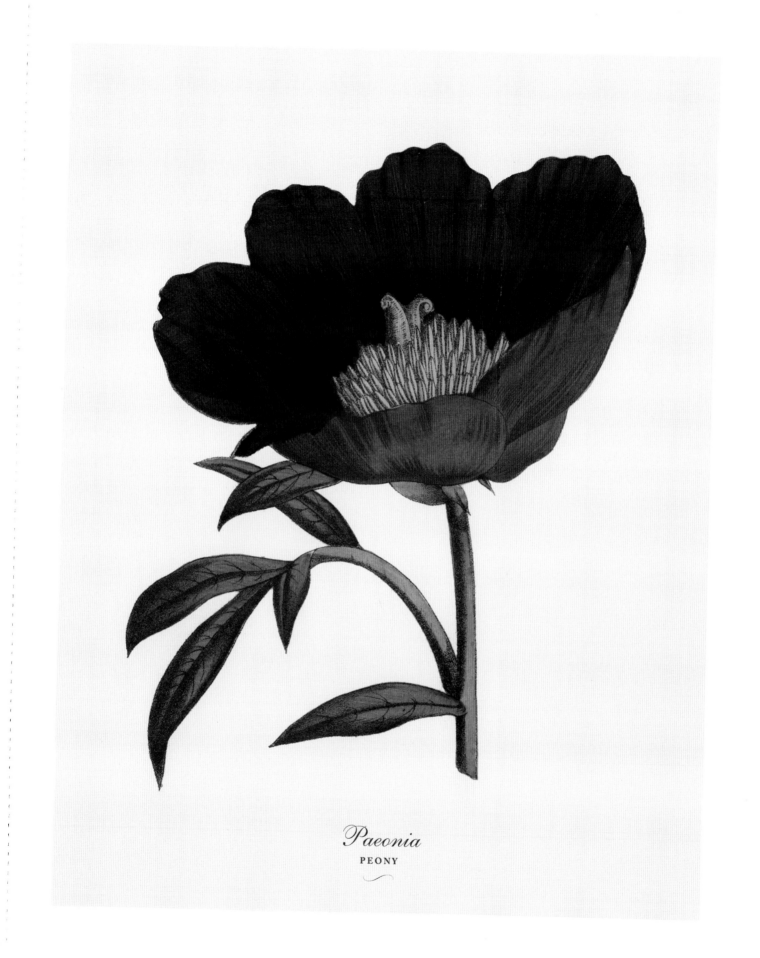

Paeonia

PEONY

Illustration © Getty Images/bauhaus1000

8" × 10"

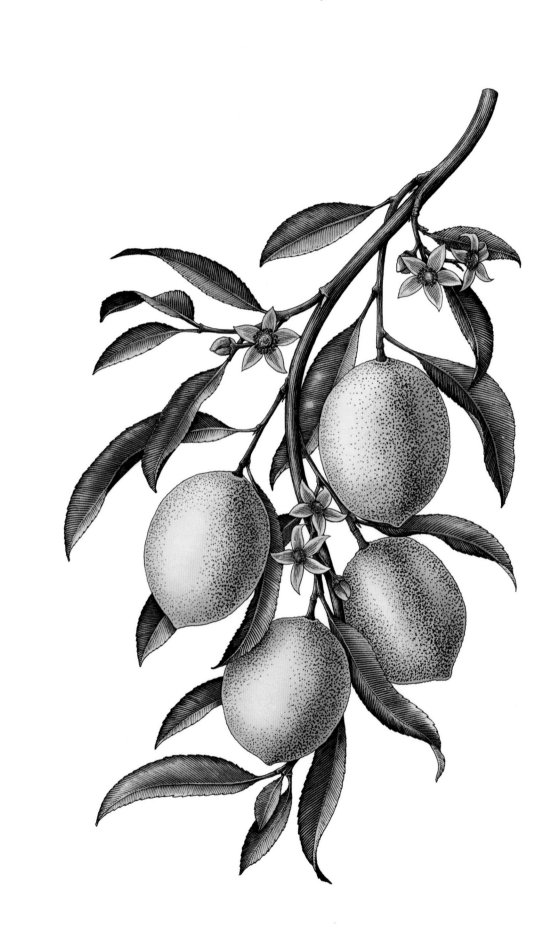

8" × 10"

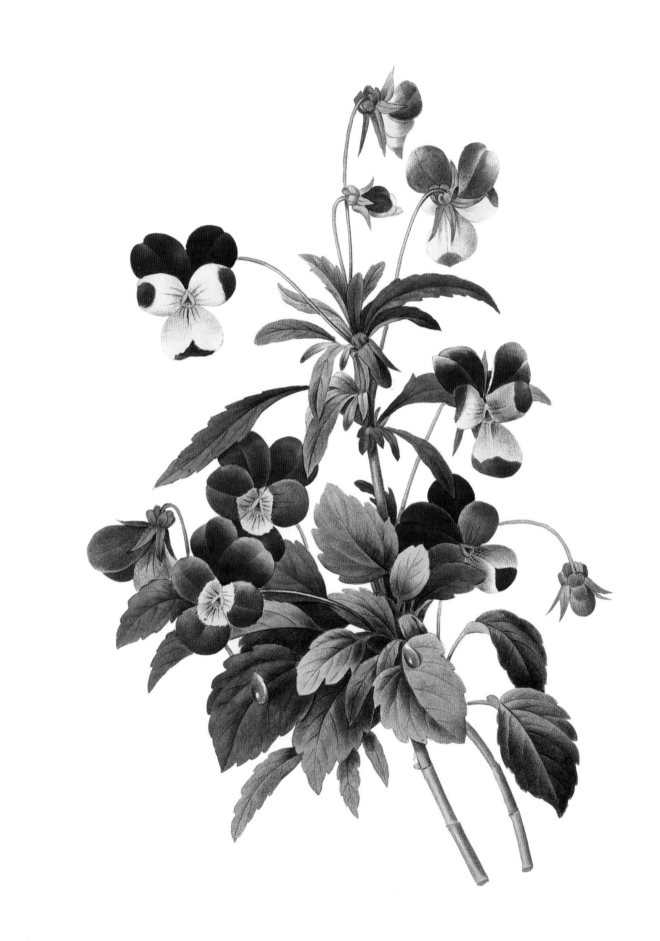

8" × 10"

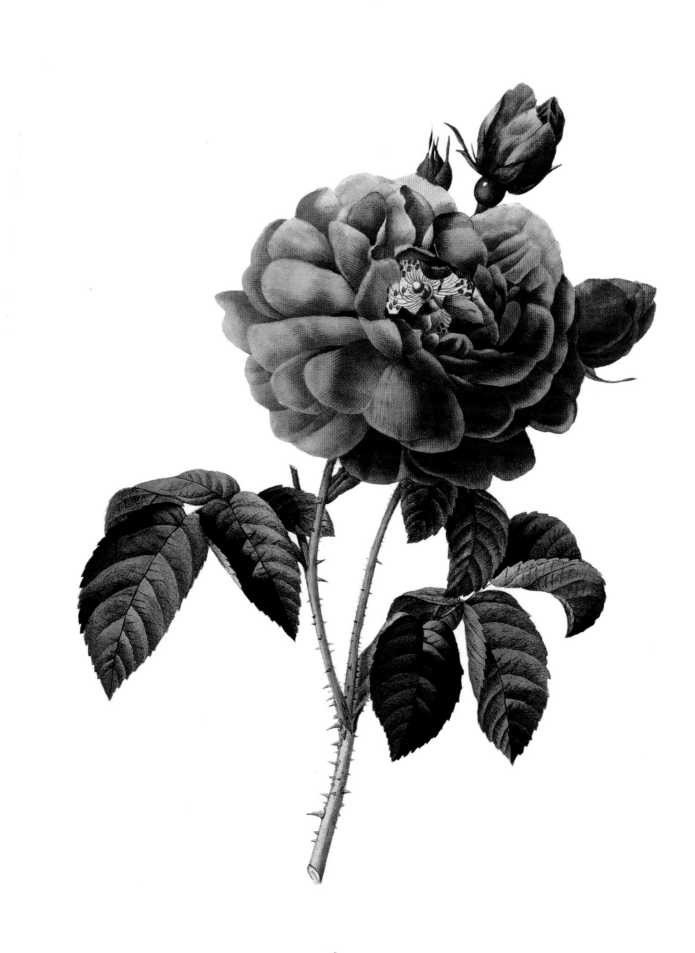

Illustration © Getty Images/NSA Digital Archive

8" × 10"

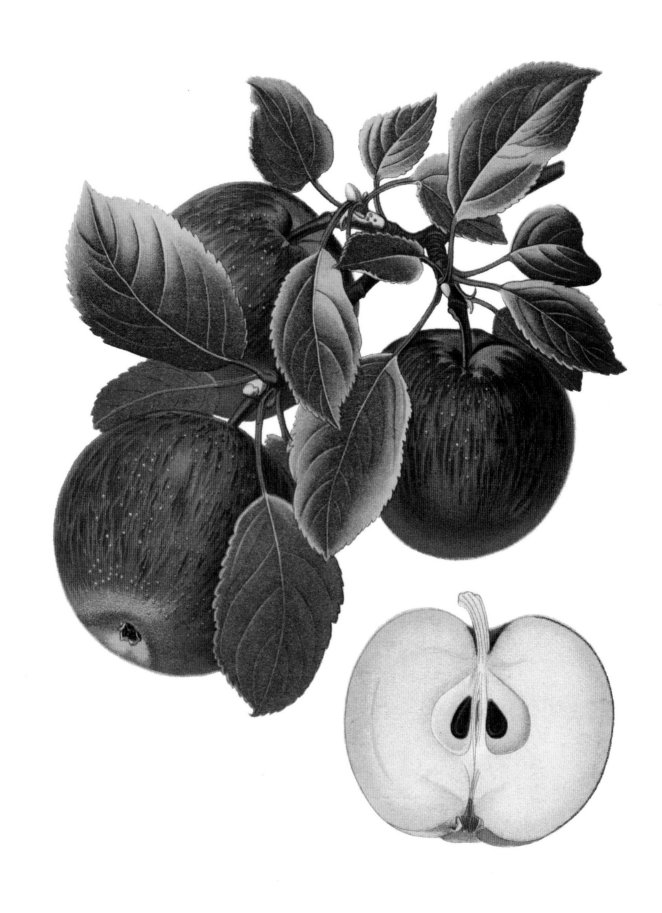

8" × 10"

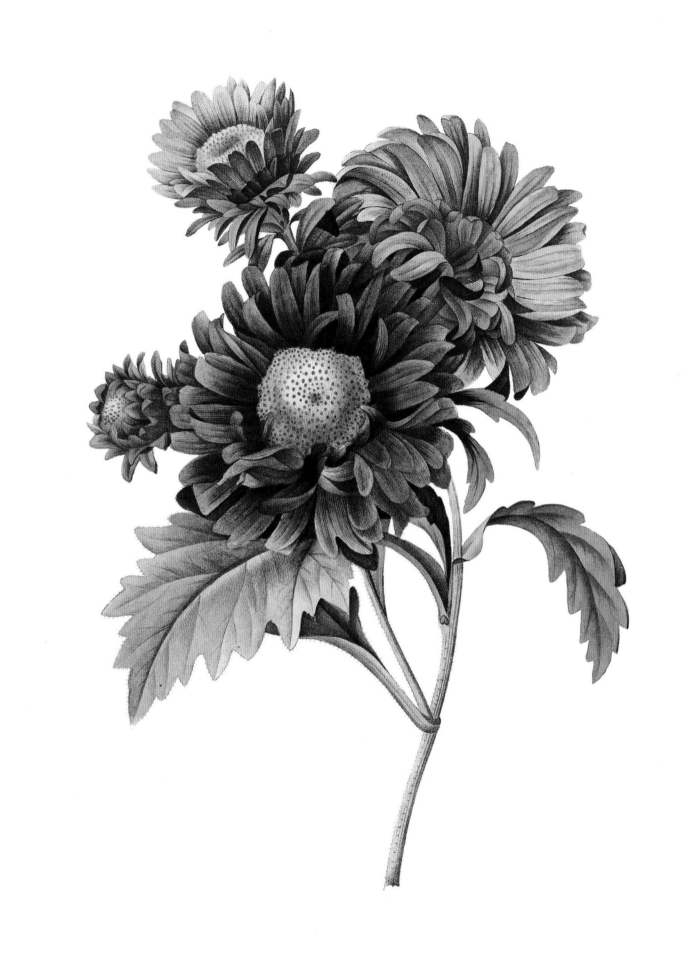

8" × 10"

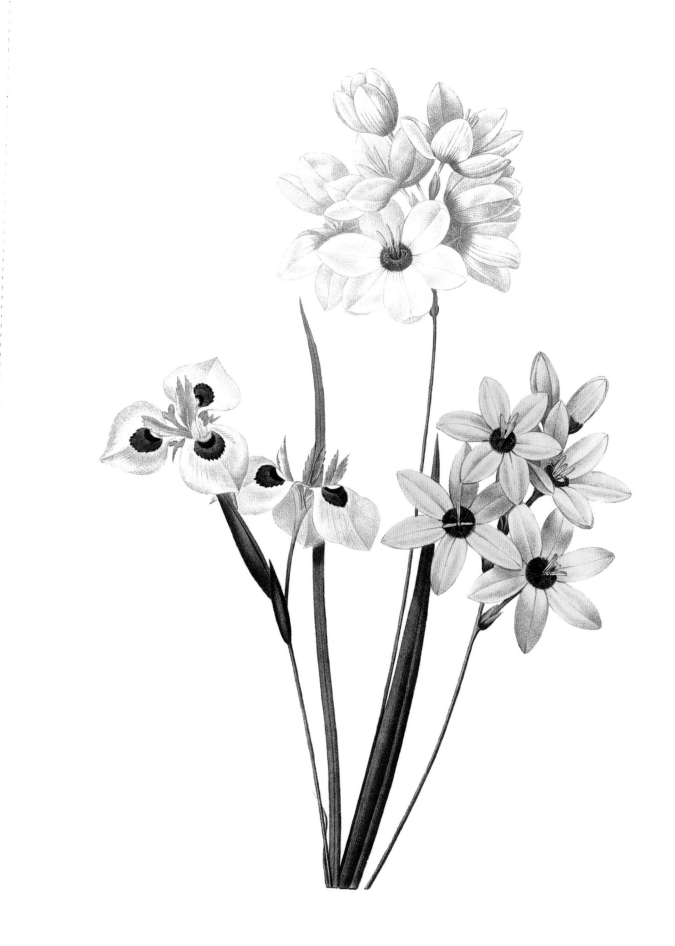

8" × 10"

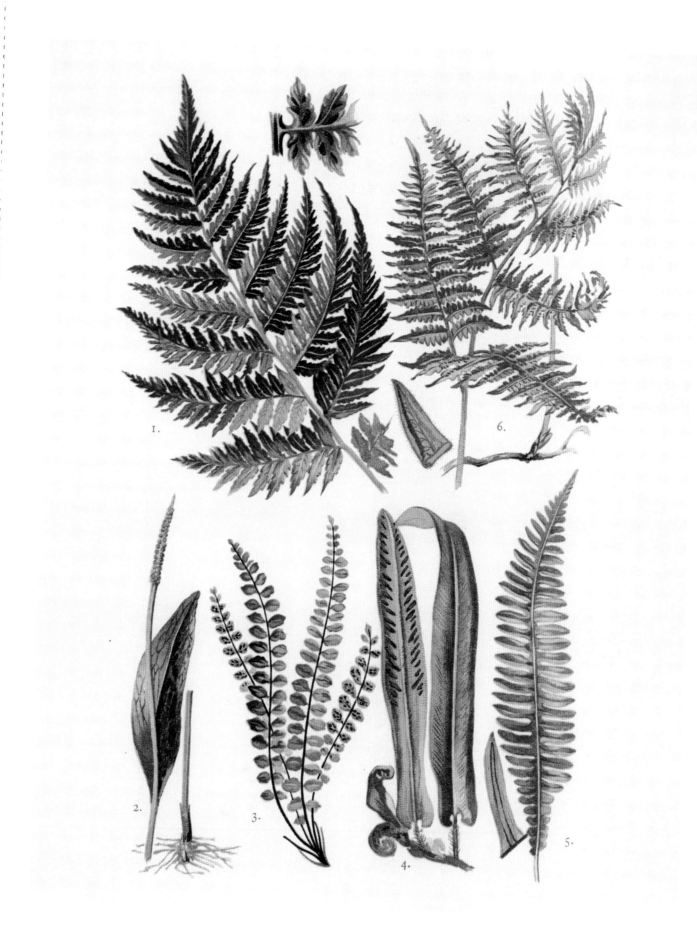

1.

2.

3.

4.

5.

6.

8" × 10"

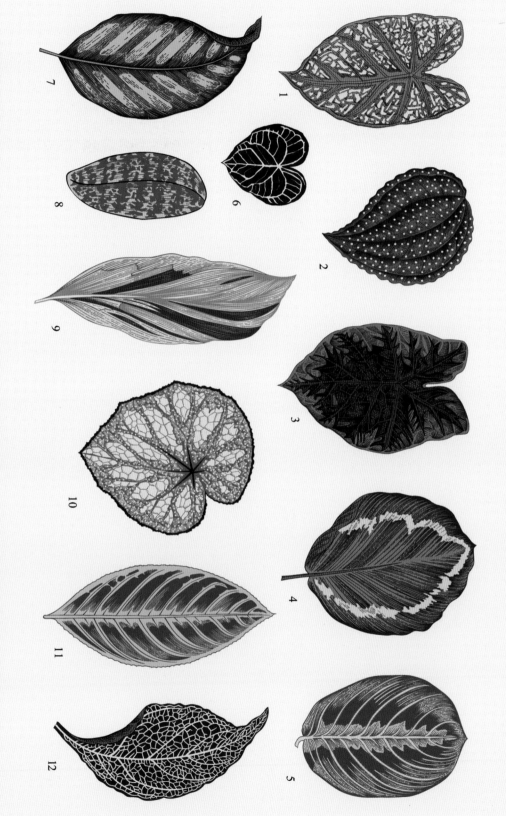

1. Caladium 2. Bertolonia 3. Caladium 4. Calathea 5. Maranta 6. Anthurium 7. Stromanthe 8. Phalaenopsis schilleriana 9. Dracaena 10. Begonia rex 11. Sanchezia nobilis 12. Fittonia albivenis

8" × 10"

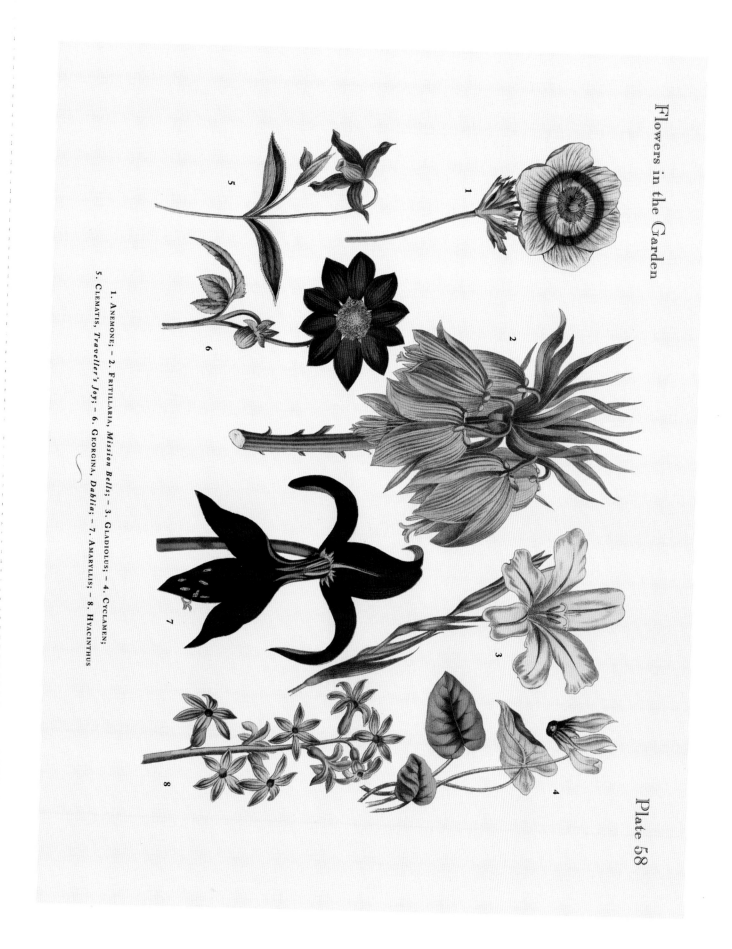

Flowers in the Garden

Plate 58

1. Anemone; – 2. Fritillaria, *Mission Bells*; – 3. Gladiolus; – 4. Cyclamen;
5. Clematis, *Traveller's Joy*; – 6. Georgina, *Dahlia*; – 7. Amaryllis; – 8. Hyacinthus

8" × 10"

Flowers in the Garden

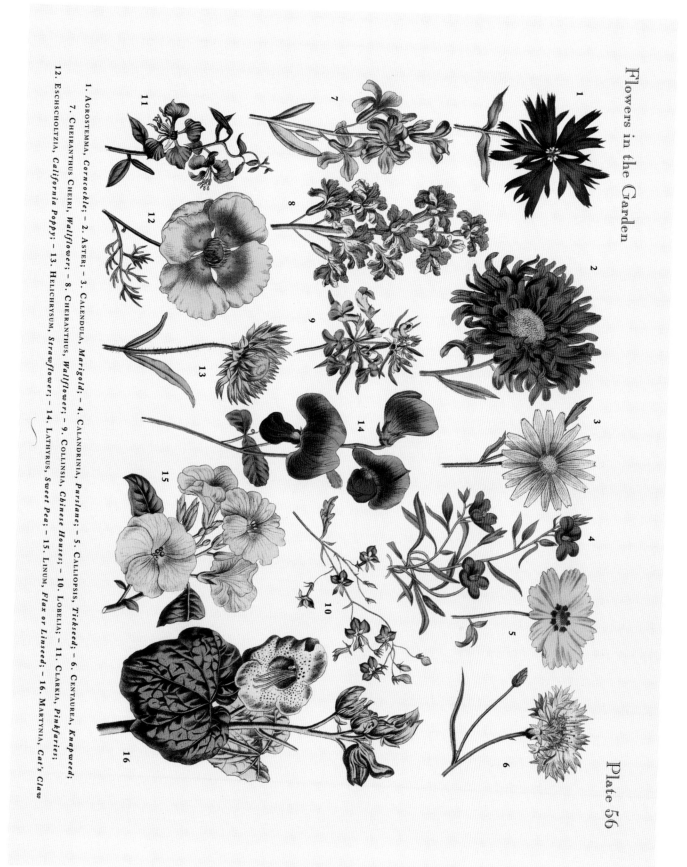

1. Agrostemma, *Corncockle*; — 2. Aster; — 3. Calendula, *Marigold*; — 4. Calandrinia, *Purslane*; — 5. Calliopsis, *Tickseed*; — 6. Centaurea, *Knapweed*;
7. Cheiranthus Cheiri, *Wallflower*; — 8. Cheiranthus, *Wallflower*; — 9. Collinsia, *Chinese Houses*; — 10. Lobelia; — 11. Clarkia, *Pinkfaries*;
12. Eschscholtzia, *California Poppy*; — 13. Helichrysum, *Strawflower*; — 14. Lathyrus, *Sweet Pea*; — 15. Linum, *Flax or Linseed*; — 16. Martynia, *Cat's Claw*

Plate 56

8" × 10"

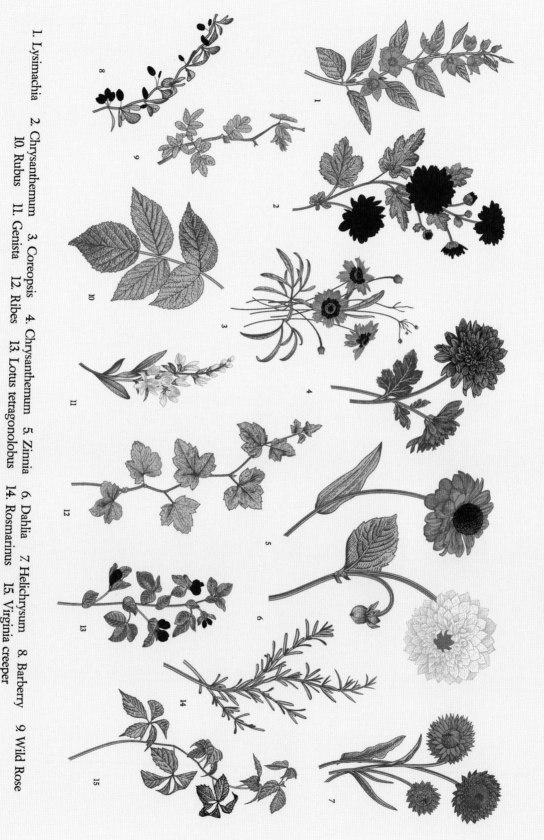

8" × 10"

Plate 11

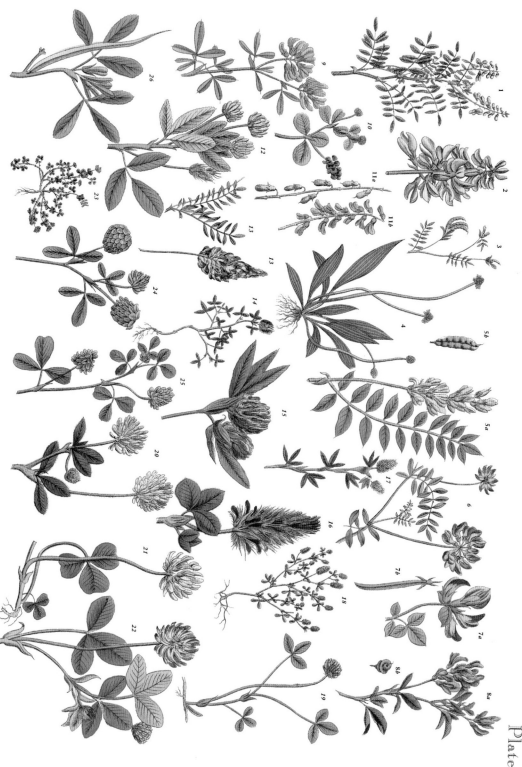

1., 2., Galega, *Goat's-rue*; – 3., Ornithopus, *Bird's-foot*; – 4., Plantago, *Fleawort*; – 5., A. B., Cicer, *Chickpea*; – 6., Coronilla, *Citrina*; – 7., A. B., Lotus, *Waterlily*;
8., A. B., Medicago sativa, *Alfalfa*; – 9., Med. falcata, *Yellow lucerne*; – 10., Med. lupulina, *Black Medick*; – 11., A. B., Melilotus offic., *Sweet Clover*; – 12., Mel. coerulea, *Blue Orchid*;
13., Onobrychis, *Sainfoin*; – 14., Trifolium medium, *Zigzag Clover*; – 15., Trif. alpestre, *Alpestre Clover*; – 16., Trif. incarnatum, *Crimson Clover*; – 17., Trif. rubens, *Rubens Clover*;
18., Trif. arvense, *Hare's-foot Clover*; – 19., Trif. fragiferum, *Strawberry Clover*; – 20., Trif. montanum, *Mountain Clover*; – 21., Trif. repens, *White Clover*; – 22., Trif. hybridum, *Alsike Clover*;
23., Trif. filiforme, *slender Hop Clover*; – 24., Trif. agrarium, *Field Clover*; – 25., Trif. procumbens, *Little Hop Clover*; – 26., Trigonella, *Fenugreek*

8" × 10"

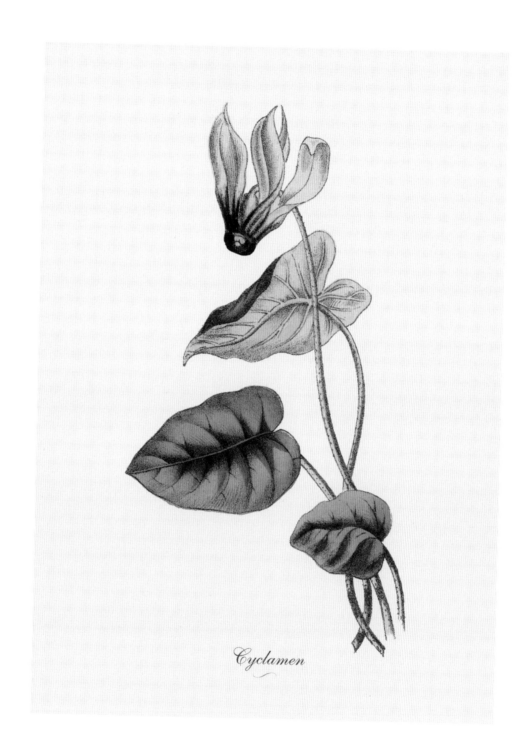

Cyclamen

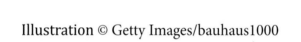

5" × 7"

8" × 10"

Tritonia

FLAME FREESIA

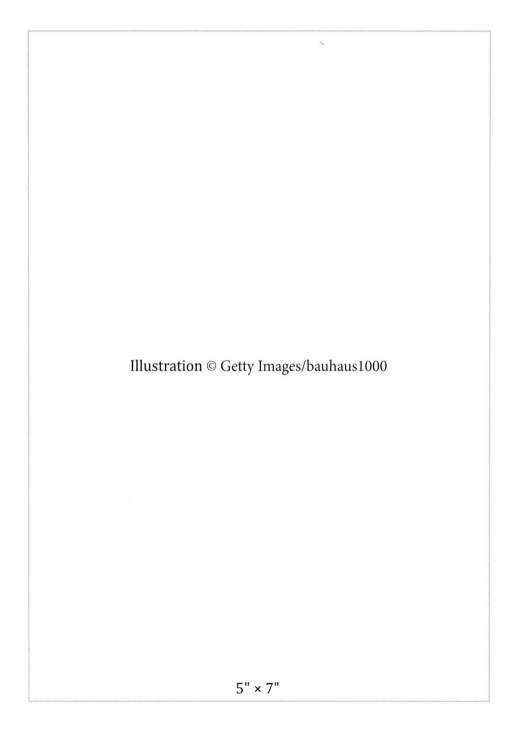

Illustration © Getty Images/bauhaus1000

5" × 7"

8" × 10"

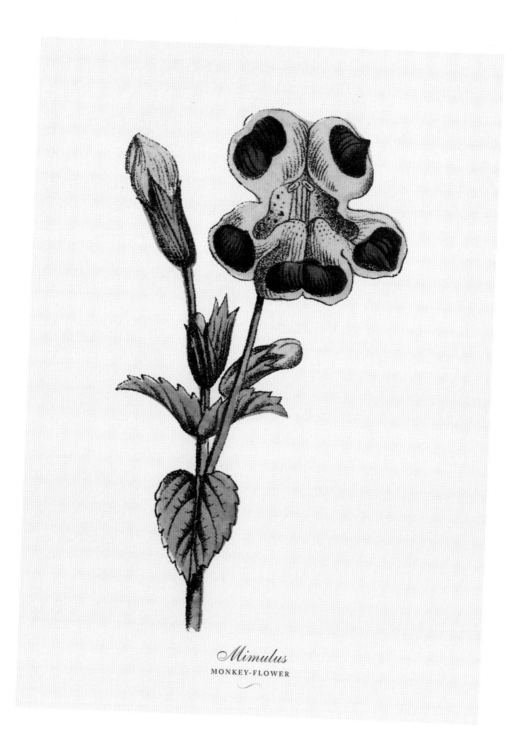

Mimulus

MONKEY-FLOWER

5" × 7"

8" × 10"

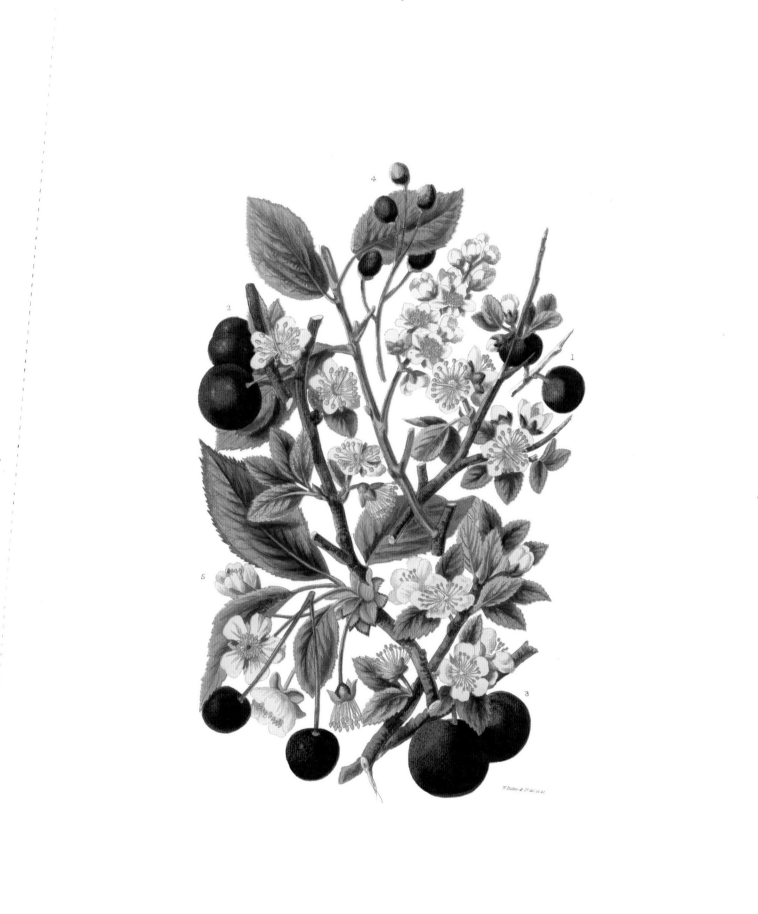

5" × 7"

8" × 10"

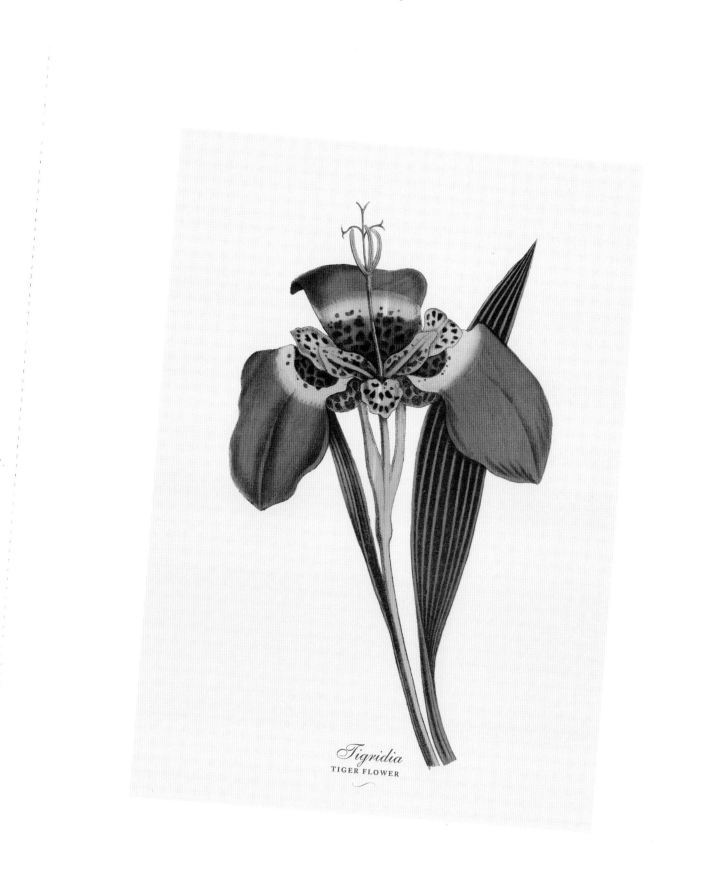

Tigridia
TIGER FLOWER

Illustration © Getty Images/bauhaus1000

5" × 7"

8" × 10"

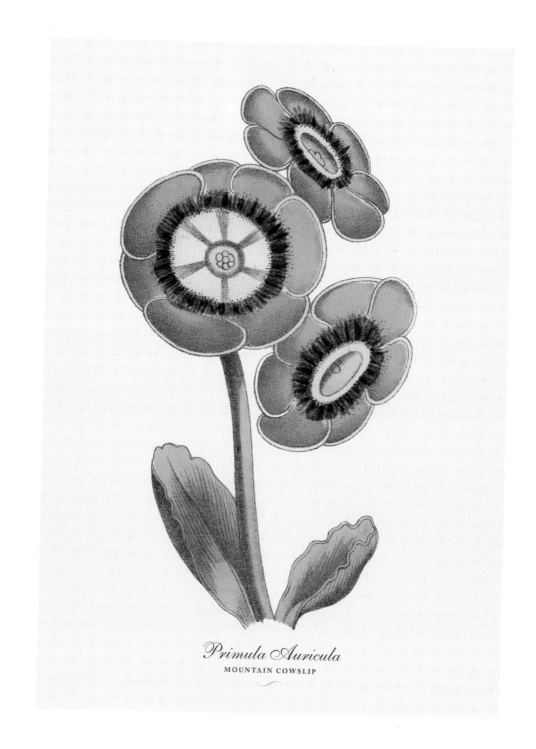

Primula Auricula

MOUNTAIN COWSLIP

Illustration © Getty Images/bauhaus1000

5" × 7"

8" × 10"

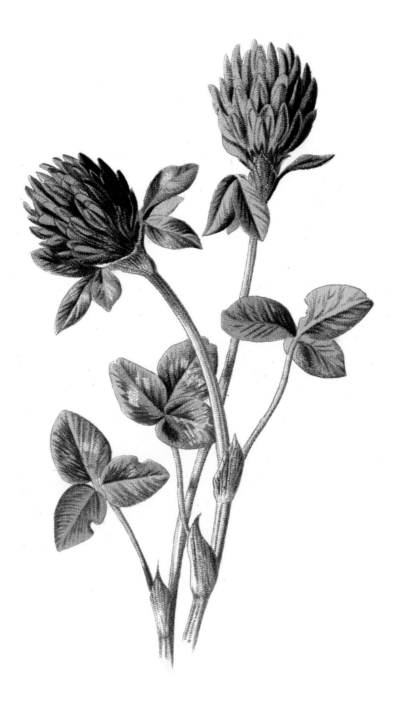

5" × 7"

8" × 10"

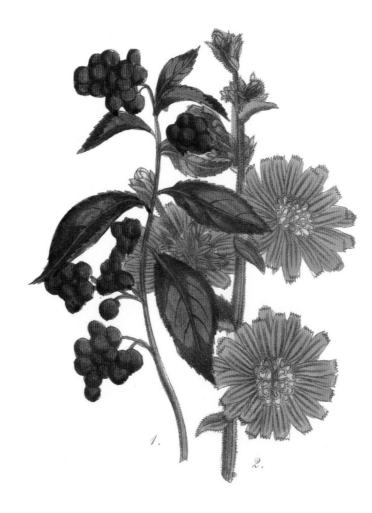

1. Bittersweet
2. Wild or Blue Succory

5" × 7"

8" × 10"

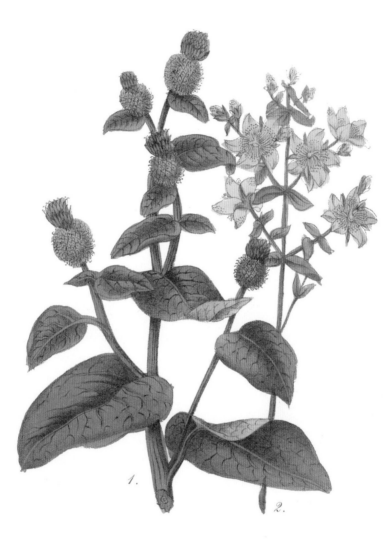

1. Burdock. 2. St. Johns Wort.

Illustration © Getty Images/bauhaus1000

5" × 7"

8" × 10"

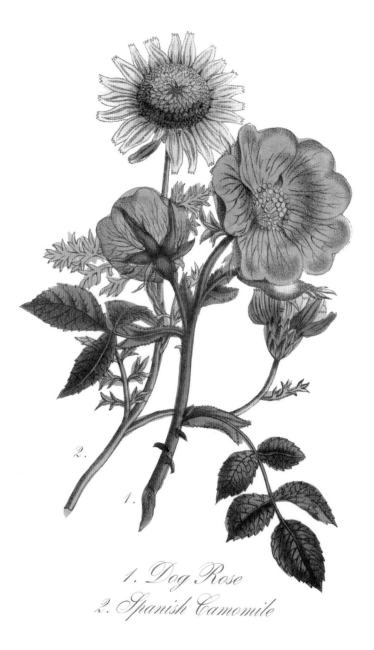

1. Dog Rose
2. Spanish Camomile

Illustration © Getty Images/bauhaus1000

5" × 7"

8" × 10"

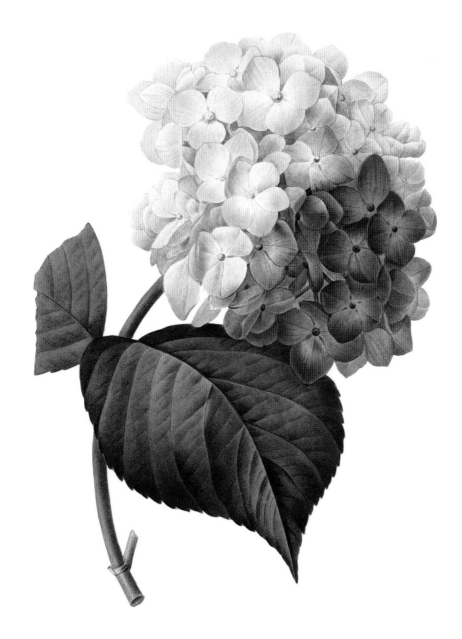

5" × 7"

8" × 10"

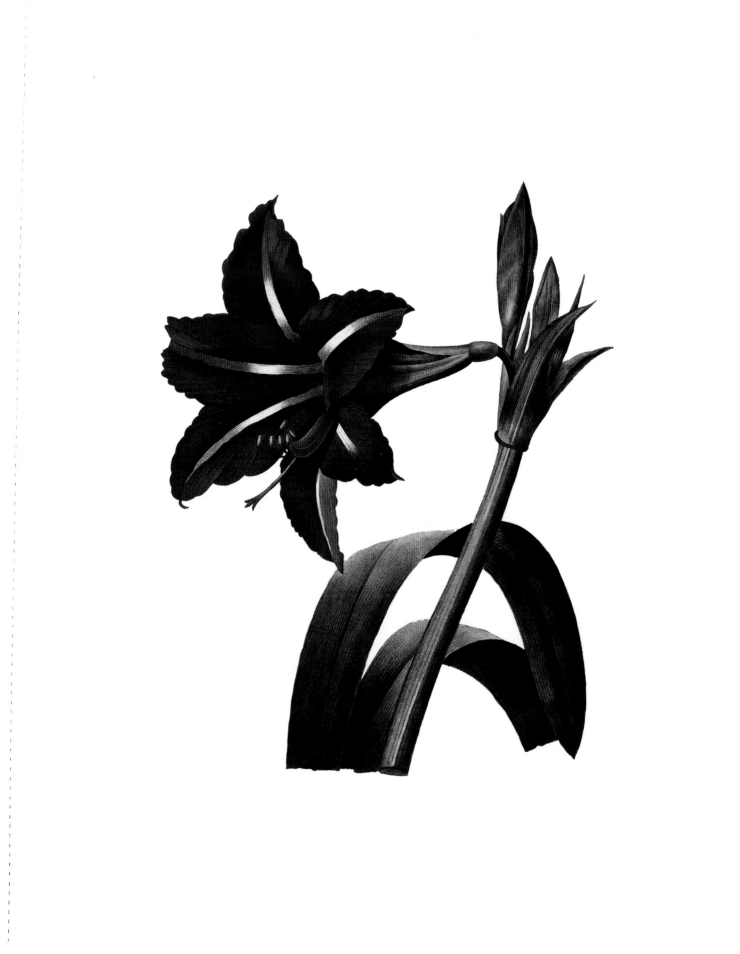

5" × 7"

8" × 10"

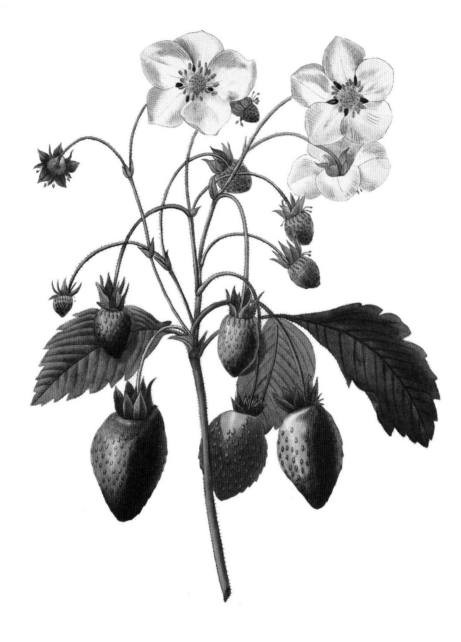

Illustration © Getty Images/NSA Digital Archive

5" × 7"

8" × 10"

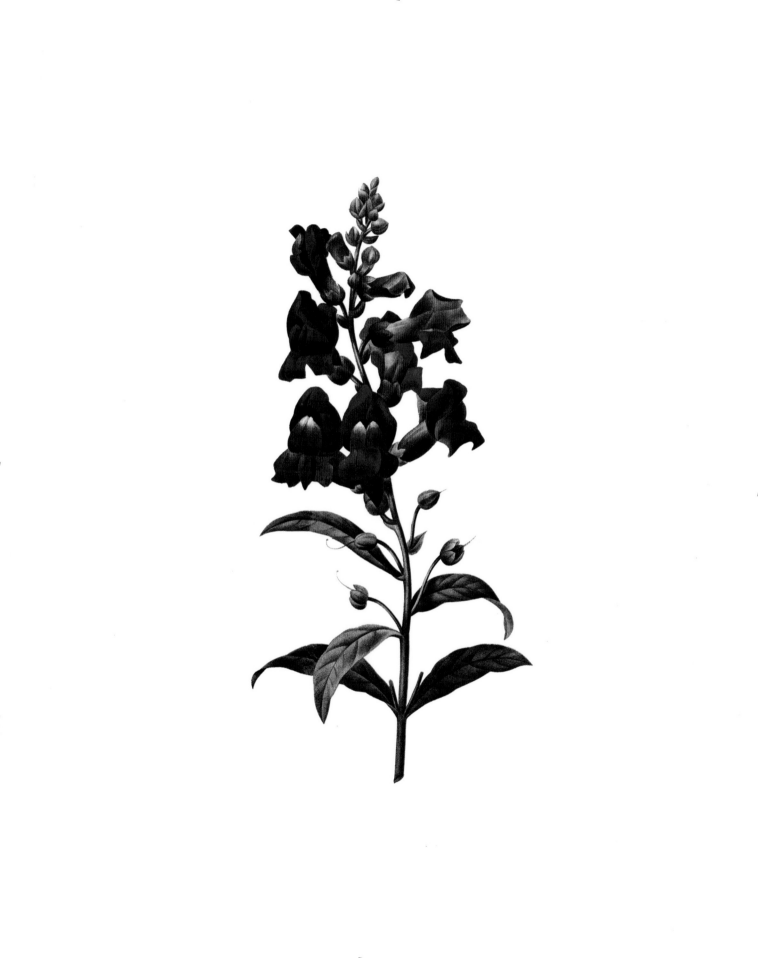

5" × 7"

8" × 10"

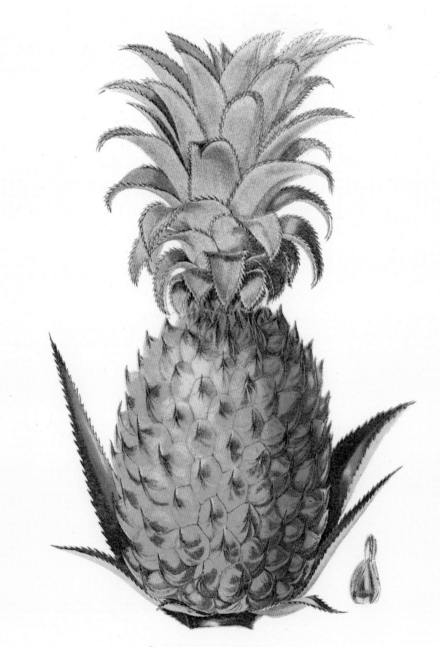

QUEEN PINE.

Illustration © Getty Images/THEPALMER

5" × 7"

8" × 10"

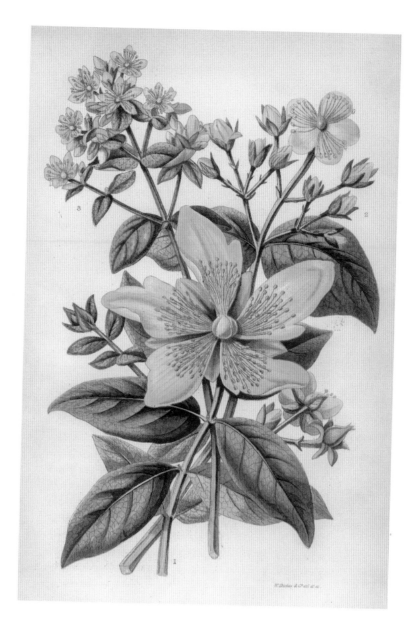

4" × 6"

5" × 7"

8" × 10"

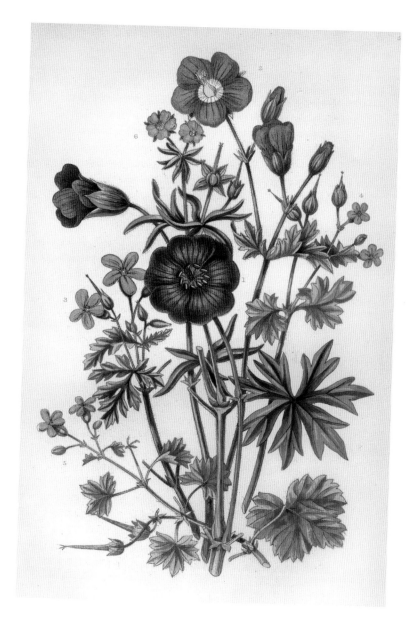

4" × 6"

5" × 7"

8" × 10"

Illustration © Getty Images/bauhaus1000

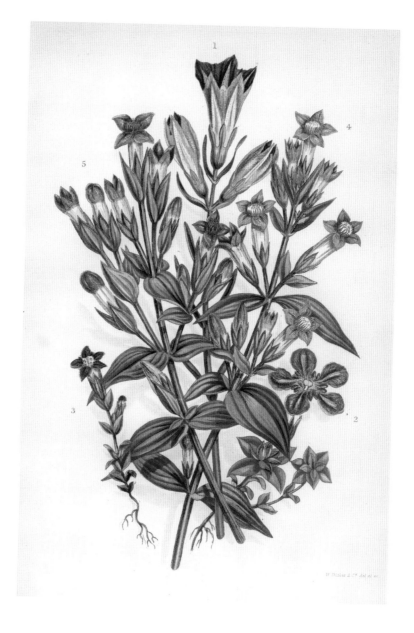

4" × 6"

5" × 7"

Illustration © Getty Images/bauhaus1000

8" × 10"

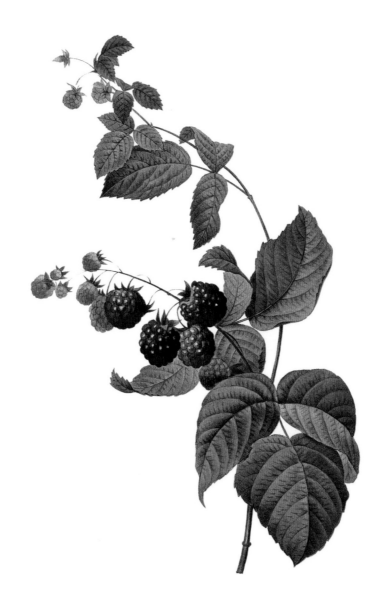

Illustration © Getty Images/NSA Digital Archive

4" × 6"

5" × 7"

8" × 10"

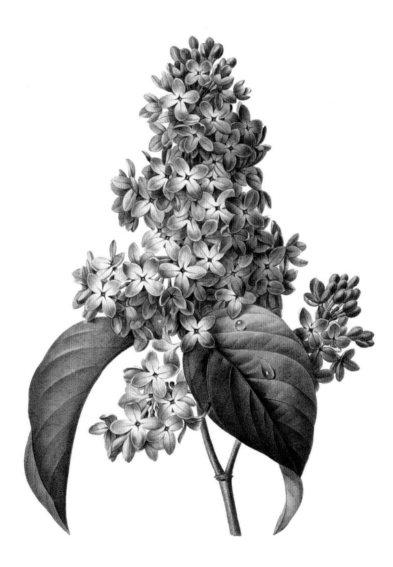

4" × 6"

5" × 7"

8" × 10"

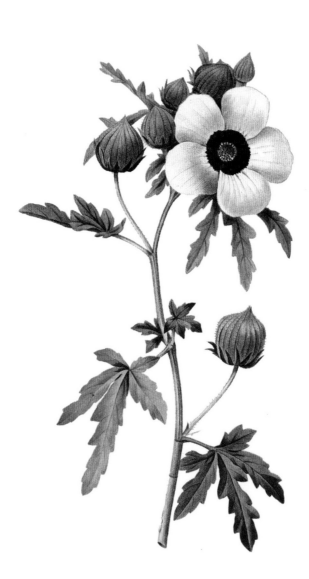

4" × 6"

5" × 7"

8" × 10"

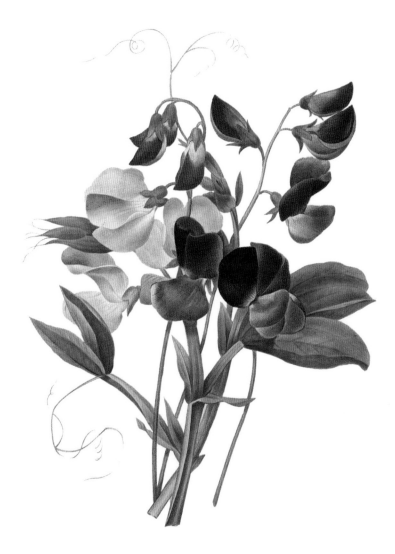

Illustration © Getty Images/NSA Digital Archive

4" × 6"

5" × 7"

8" × 10"

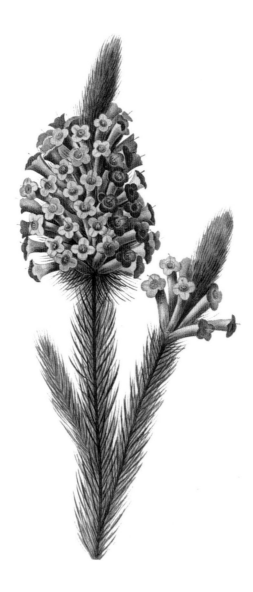

4" × 6"

5" × 7"

8" × 10"

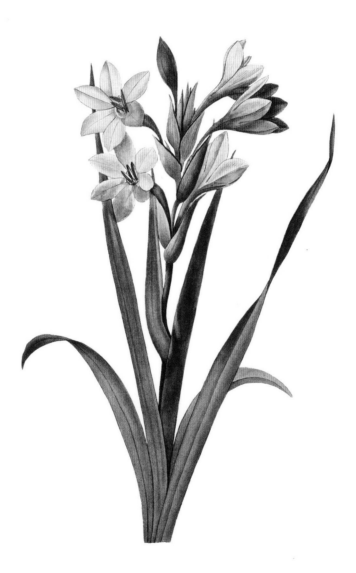

4" × 6"

5" × 7"

Illustration © Getty Images/NSA Digital Archive

8" × 10"

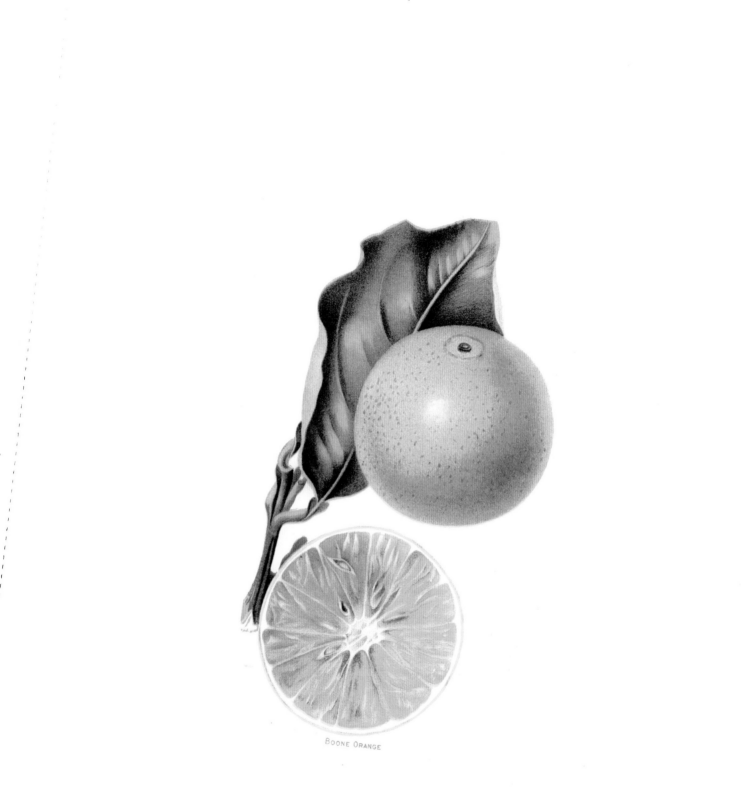

BOONE ORANGE

4" × 6"

5" × 7"

Illustration © Getty Images/THEPALMER

8" × 10"

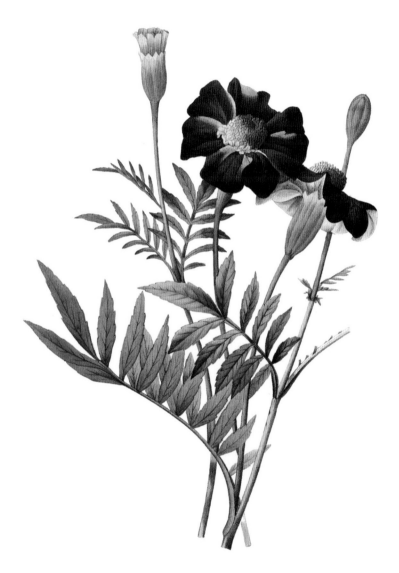

4" × 6"

5" × 7"

8" × 10"

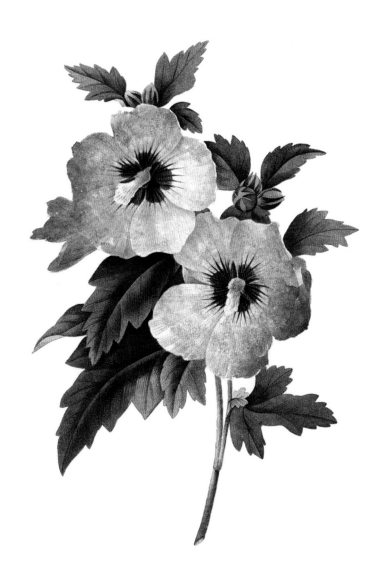

4" × 6"

5" × 7"

8" × 10"

Illustration © Getty Images/NSA Digital Archive

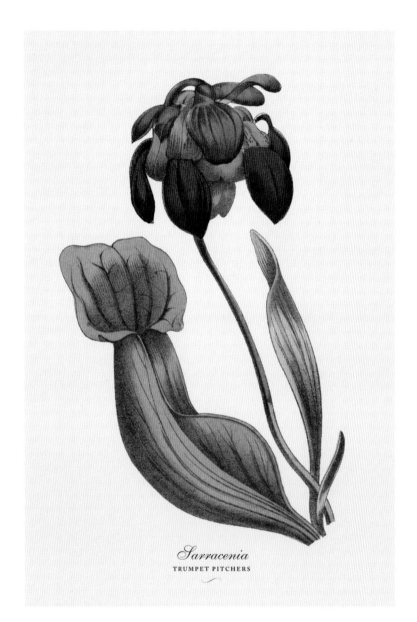

Sarracenia

TRUMPET PITCHERS

Illustration © Getty Images/bauhaus1000

4" × 6"

5" × 7"

8" × 10"

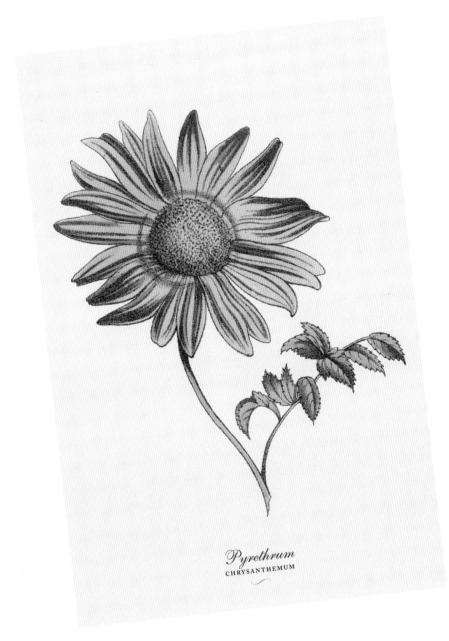

Pyrethrum
CHRYSANTHEMUM

4" × 6"

5" × 7"

Illustration © Getty Images/bauhaus1000

8" × 10"

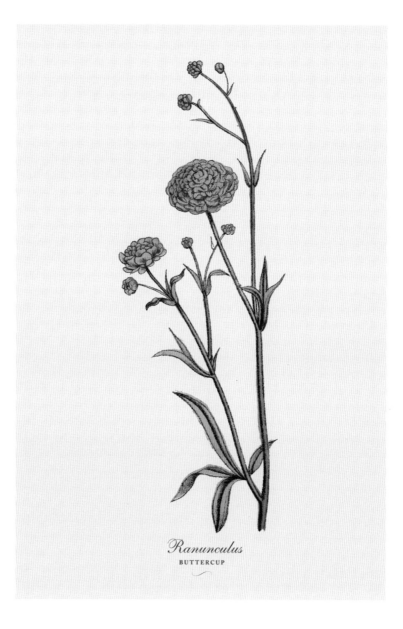

Ranunculus

BUTTERCUP

4" × 6"

5" × 7"

8" × 10"